Keeping a Watercolor Sketchbook

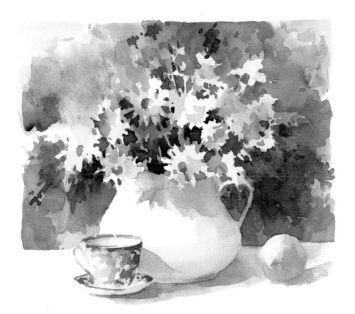

by Brenda Swenson

Brenda would like to thank her family, friends, and students for their love, encouragement, and belief in her work.

Walter Foster Publishing, Inc.
23062 La Cadena Drive
Laguna Hills, CA 92653
www.walterfoster.com

Contents

Introduction

Using the Sketchbook As an Artist's Tool

Nearly 10 years ago, I was challenged to complete a sketch a day over the course of 10 weeks. At first, the challenge appeared to be a simple exercise, but I gradually came to see it as one of the greatest lessons of my artistic career. In the past, I would labor over drawing for so long that I would become apprehensive about beginning to paint. But by sketching daily, I found I was no longer struggling each time I picked up a pencil. As the weeks went by, I watched my work improve by leaps and bounds. The challenge freed me to create in ways I never had before!

The most valuable lesson I learned is that keeping a watercolor sketchbook isn't about making perfect renderings—it's about observing and gathering visual information. Watercolor sketches are somewhat loose by nature, which is part of their charm. These playful-looking renderings can be complete in themselves, or they can act as a road map to larger studio paintings. Today I use sketchbooks for developing location studies, creating travel journals, designing paintings, making color mixtures, taking notes, and so much more! I've filled dozens of these books over the years, and they've become like old friends to me.

Now I'm rarely without a sketch-book. Starting a new book is like embarking on a journey; as I begin each one, I wonder where it will lead me and what lessons I'll learn along the way! I welcome the opportunity to share my joy of sketching with you and to help provide the information and tools you'll need to set out on your own sketchbook adventures.

"A work of art is a world in itself, reflecting sense and emotions of the artist's world." —Hans Hoffman

Selecting Tools and Materials

An artist's tools and materials are very personal things! Over time, I've developed my own favorites, which I've outlined on these pages to help you get acquainted with your options. But I've found there's no such thing as a magic tool; whatever you're most comfortable with is usually best. As you begin exploring the art of watercolor sketching, I'm sure you'll develop your own favorites!

Sketchbooks

There are all kinds of sketchbooks available on the market, but I like the spiral-bound ones best because they lie flat when opened. I use a variety of sizes, from 6" x 9" to 11" x 14". I steer away from books with thin paper; denser papers are better able to handle washes of color without the color bleeding through or the paper warping.

Spiral-bound sketchbooks allow you to remove and replace pages—an advantage if you like to share or frame your sketches.

Smooth paper

Medium paper

Rough paper

Paper Textures Watercolor paper comes in different weights, designated in pounds. The higher the number, the heavier the paper. Paper also comes in various surface textures. Hot-press (left), cold-press (center), and rough (right) papers will each absorb paint differently. Choose a paper according to your subject—for example, the texture of rough paper can be good for outdoor scenes.

Working with Water-Soluble Pens

Water-soluble pens contain ink that dissolves in water. I often sketch with these pens because I can apply water or watercolor to the marks to create washes, blends, and other exciting effects!

◄ **Water-Soluble Pens** As do regular pens, water-soluble pens can create distinct lines (top); but you can also overlap the ink with water (center) or blend into it with watercolor (bottom).

Considering Easels

An easel allows you to angle your paper from flat to vertical; this way thin washes run down the page instead of pooling.

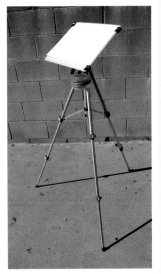

Choosing a Palette

Watercolors come in hardened cakes or in tubes. Folding travel palettes have wells that accommodate both types; you can fill the wells with your own cake colors or squeeze in tube colors. I prefer tubes because they activate with just a little water, and they allow me to easily match on-location colors when working in my studio.

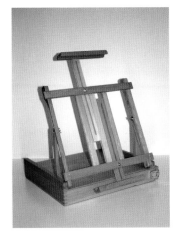

Studio Easel When painting indoors, I use a small easel to hold my painting in place.

Travel Easel When painting outdoors, I use an easel my husband created. An acrylic surface that supports my paper or sketchbook is attached to a lightweight, tripod base.

Buying Pencils and Erasers

For drawing, I use soft HB and 2B pencils; whereas I favor an even softer (and thus darker) 4B mechanical pencil for value studies.

Erasers aren't all made alike. Kneaded erasers are great for "lifting out" light values, and they're gentle enough to use on delicate papers. White vinyl erasers are still somewhat soft, and they won't stain paper.

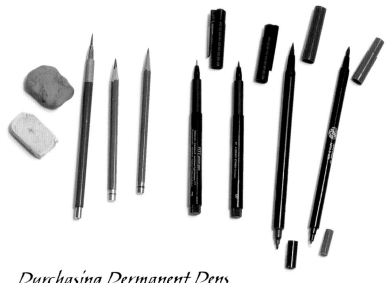

Purchasing Permanent Pens

For making notes and sketches, I like to use archival-quality pens. Using high-quality, indelible pens ensures that, when I open my sketchbook to a favorite scene, I won't find a terrible green stain in place of my writing or picture!

Deciding on Paints

As I've already mentioned, both tube and cake paints are good choices for portability, but I prefer tube paints. (See page 5.) Watercolors come in two qualities: artist grade and student grade. I encourage you to buy artist grade paints; even though they are a little more expensive, the colors are richer and the pigments are longer-lasting. My basic color palette consists of 16 colors. You really need only a few colors to start—one warm and one cool version of each of the *primary colors* (red, blue, and yellow). In theory, you can produce any other color by mixing the primary colors. (See page 8 for more on color mixing.) You can create a beautiful range of colors with a few well-chosen pigments; I normally don't use more than eight colors for a sketch.

Because I maintain the same basic palette, I know what to expect from my colors and mixes.

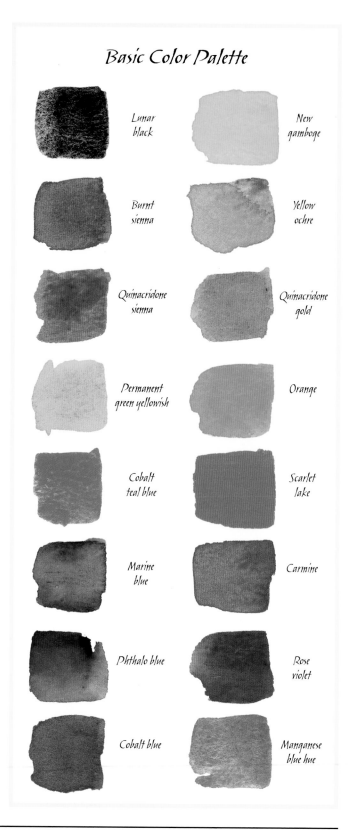

Basic Color Palette

Lunar black	New gamboge
Burnt sienna	Yellow ochre
Quinacridone sienna	Quinacridone gold
Permanent green yellowish	Orange
Cobalt teal blue	Scarlet lake
Marine blue	Carmine
Phthalo blue	Rose violet
Cobalt blue	Manganese blue hue

Choosing Brushes

Paintbrushes come in two hair types—synthetic and natural. At one time, natural brushes were of a higher quality than synthetic; but the quality of synthetic brushes has improved greatly over the years. I use only synthetic brushes— they're less expensive, and I like the way they work!

▶ **Paintbrushes** I keep a supply of assorted round brushes on hand (choosing a size appropriate for the subject), as well as two flat brushes—one medium and one large. I also use a stiff oil painting brush (near left) for lifting techniques.

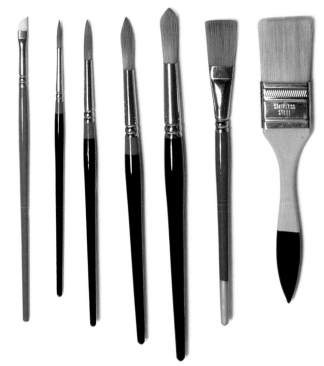

Using Sponges

In watercolor, sponges are about as versatile a tool as you can get! Artists use sponges to control water, lift out color, wet paper, or even create texture or special effects. I always keep a thin, flat sponge to the side of my palette. Each time I rinse my brush, I tap the brush on the sponge before picking up paint with it, ensuring that my paint isn't over-diluted!

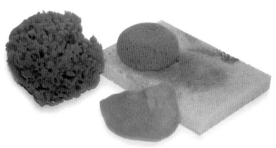

Sponges Experiment with a variety of sponge types, shapes, and sizes to find ones that suit your needs.

Gathering Additional Items

There are a few other items you may find helpful to have on hand, such as paper towels for cleanup and a spray bottle for lightly misting your paints to keep them fresh. Although many artists use two water containers—one for rinsing brushes and one for clean water—I use only one container, refilling it with fresh water whenever needed. When I'm planning to stay outdoors for a while, I bring along a few more supplies for comfort. (See page 35.)

Studio In my work space, all my tools are within reach.

Understanding Color

When used correctly, color will help you express your feelings about a location or the subjects you sketch. I'm not overly concerned about recording *local color* (the term used when describing the actual color of an object). Instead I use colors that express the essence of a scene, choosing colors that emphasize how I feel when I am there. Unlike local color, *personal color* expresses how you feel about what you see. The reason I enjoy sketching so much is that it gives me the freedom to explore and respond to a particular place and

time—for example, recording colors that reflect my emotional responses to a subject rather than stark reality. In my mind's eye, that is the important difference between sketching and photographing.

Color Mixing

Artists turn to color mixes to express their artistic vision, rarely using *pure color*—that is, paint straight from the tube. For a homogeneous look, you can mix colors directly on the palette. You can also visually mix colors using *glazes*—thin, transparent applications of color. You can also mix color by painting *wet-into-wet*—applying wet paint to damp paper or into wet color so the colors bleed into one another.

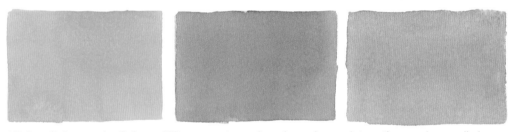

Mixing Color on the Palette When you mix on the palette, the result is uniform and controlled.

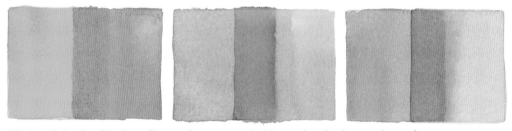

Mixing Color by Glazing Glazing allows you to build up color slowly on a dry surface.

Mixing Color by Painting Wet-into-Wet This technique produces exciting, unpredictable blends.

Exploring Color Relationships

For a good introduction to color, I encourage you to make your own color wheel. The wheel centers around the three primary colors—red, yellow, and blue. These colors can't be created by mixing any other colors. If you mix two primaries together, you produce a *secondary* color—orange, green, or purple. And when you mix a primary with a secondary, you create a *tertiary* color, such as blue-green or red-orange. Artists talk about both colors and their variations, or *hues*. All blue colors are close in hue; but each blue—such as cobalt blue, marine blue, or indigo—is a separate hue. (For more about color and color relationships, see page 26.)

▶ **The Color Wheel** The color wheel is an essential tool for visualizing aspects of color theory and relationships among colors.

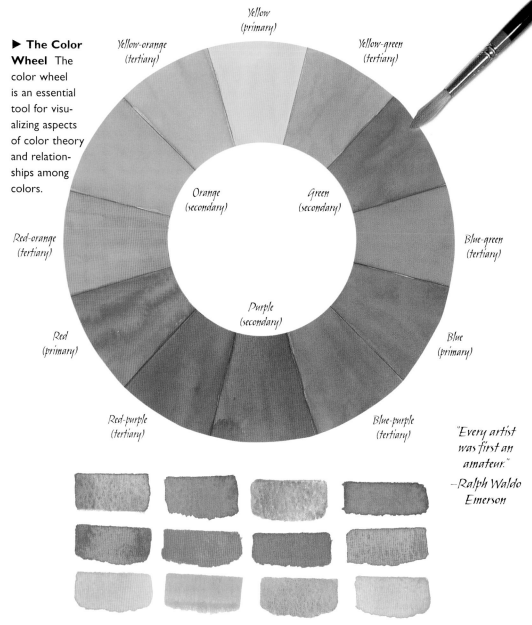

Yellow
(primary)

Yellow-orange
(tertiary)

Yellow-green
(tertiary)

Orange
(secondary)

Green
(secondary)

Red-orange
(tertiary)

Blue-green
(tertiary)

Purple
(secondary)

Red
(primary)

Blue
(primary)

Red-purple
(tertiary)

Blue-purple
(tertiary)

"Every artist was first an amateur."
–Ralph Waldo Emerson

Varying Hues Each color has many hues; this example shows a sampling of each primary color's hues.

Seeing Values

What is *value*? It's the way the eye reads light or dark. Most people are familiar with a gray scale of values (below, top), but colors also have a scale of tonal values (below, bottom). Yellows have the lightest hues, greens and reds have mid-range hues, and purples have the darkest hues. It's easier to see values when squinting—maybe that's why so many of us artists have more wrinkles around our eyes!

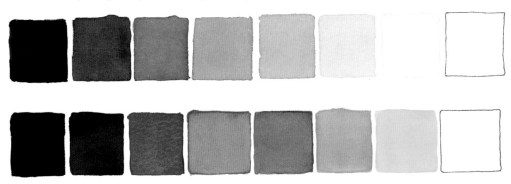

Saving and Retrieving Whites

Because there isn't any white paint in watercolor, the white of the paper is very valuable to watercolorists. In most instances, we have to "save" any white we want in a sketch by painting around it; occasionally we are also able to "retrieve" whites by removing color from our paper. (For more on painting and retrieving whites, see pages 52–55.)

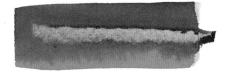

Masking Fluid This rubbery substance can mask whites. Apply the mask, paint over it, and then rub off the mask when the paint is dry.

Lifting Color with Masking Protect the surrounding color with artist's tape, then lightly scrub with a damp sponge to remove color.

Scraping with a Razor For small areas, you can apply a razor to already-dried paint to gently scrape off lines of surface color.

Lifting Color without Masking Using a stiff brush loaded with clean water, gently scrub the paper to remove color.

Scraping with a Knife When damp paper has just lost its shine, you can use a palette knife to scrape off color.

Testing Translucency

Although watercolor is a translucent medium, not all paint colors are equally transparent. Knowing the strength of your colors' transparency will help you predict how the colors will interact. Test each watercolor's opacity by painting it over a dry band of waterproof black ink. If the hue is visible on top of the line when the paint is dry, the color is opaque. You can also try overlapping different colors from your palette to avoid surprises when you combine the paints in your sketches.

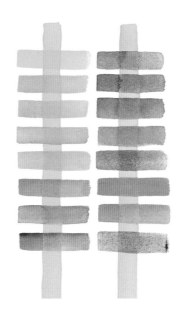

▶ **Overlapping Colors to Test Transparency** Colors that are more opaque than the yellow shown here (new gamboge) will seem to float above the yellow line, whereas colors that are more transparent will seem to sink below it. Even semi-opaque colors will appear transparent if diluted with enough water.

Glazing Colors

Because of their transparent nature, watercolors can be glazed on top of one another. The undercolor will affect the top color, but the effect varies depending on the transparency of the colors used. Paints with the same quality of transparency will produce more equal visual blends.

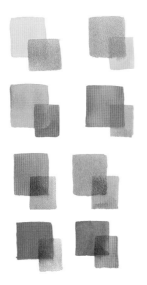

Granulating Colors

Certain pigments (such as manganese blue, raw sienna, and cobalt blue) *granulate*—meaning their pigments separate from the binder and settle into the grooves of textured paper. These colors can produce exciting effects, especially when depicting rusted metal, rocks, or wood. Experiment by mixing them with other colors (below), or try them alone.

Mixing Greens

You may have already noticed that I don't keep any green paints on my palette. I find that the ranges of greens I can mix with my existing colors are richer, more varied, and more natural than those that come straight from the tube. Try mixing the blues and yellows from your palette to sample some of the many possible combinations!

"There is no 'must' in art because art is free." —Wassily Kandinsky

Developing a "Seeing Eye"

There is a big difference between sketching what you *actually* see and sketching what you *think* you see. Because we have expectations about what we will see, in truth, we spend very little time looking. Take a few minutes to explore with your eyes. Don't just register the objects around you, but look at their shape—or the many shapes that comprise one object. Notice how light affects the edges of objects, and pay attention to whether the shadows are long or short. Then note if the colors are bright or muted. If you take the time to slow down enough to *really* look at the world around you, you may find that you begin to see things in a different way—and you may even see some things for the very first time!

Simplifying Objects into Shapes and Forms

Every object is a three-dimensional form based on some combination of four basic geometric shapes: the circle, oval, rectangle, and triangle. Learning to see and recognize the shapes and forms in the objects surrounding you is essential if you want to create realistic sketches. It's much easier to depict an object once we are able to break it down into simple shapes and forms!

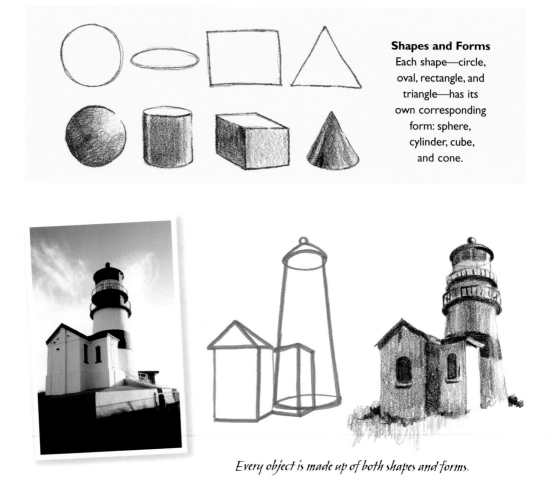

Shapes and Forms
Each shape—circle, oval, rectangle, and triangle—has its own corresponding form: sphere, cylinder, cube, and cone.

Every object is made up of both shapes and forms.

Drawing the Contours

Contour drawing is an excellent way to exercise your observation skills because it forces you to slow down and concentrate on the subject at hand. To create a contour drawing, first acknowledge the overall shape of your subject; then concentrate on one edge—or contour—at a time. To make a contour drawing, carefully draw each edge as you follow it with your eyes. Focus on one edge at a time and draw exactly what you see. There's beauty in a well-done line drawing!

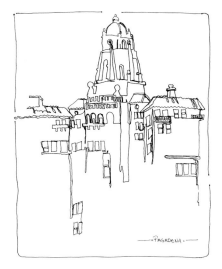

If you would like to challenge yourself, you can also try making a continual-line contour drawing. With this approach, you draw the entire subject entirely without ever lifting your pen! Find a starting point, place your pen on the page, and begin drawing the outline of your subject. Don't pick up the pen until you have finished! The subject usually becomes a little distorted when working this way, but I think of the distortion as part of the charm.

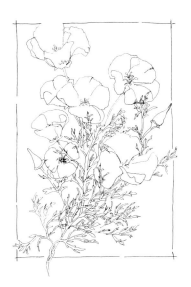

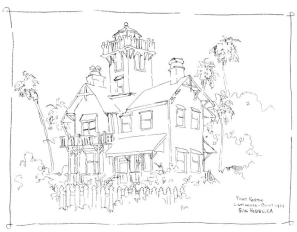

Contour drawings are direct and honest representations of what you see—and they allow you to say so much with so little!

Taking Visual Shorthand

Like most of us, I've developed my own personal "short-hand," incorporating abbreviations and symbols that may not make sense to anyone but me when I jot down to-do lists or reminders for myself. It's not important for anyone else to understand what my lists mean—just as long as I can! Sketching shorthand works the same way. Artists often use visual shorthand to quickly record just enough information to jog their memories. I'll introduce a few styles of sketching shorthand here, but your own shorthand doesn't need to follow these examples; after all, it doesn't need to make sense to any-one but you!

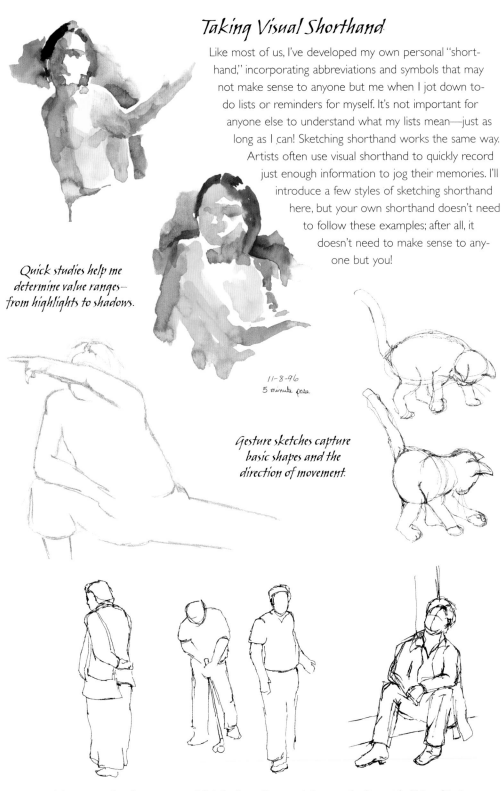

Quick studies help me determine value ranges—from highlights to shadows.

11-8-96
5 minute pose

Gesture sketches capture basic shapes and the direction of movement.

With contour sketches, I can establish basic outlines and shapes—the figures' building blocks.

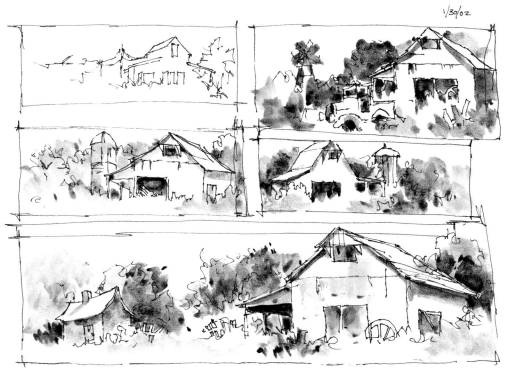

1/30/02

Play with value and composition variations using
miniature studies or "thumbnail sketches."

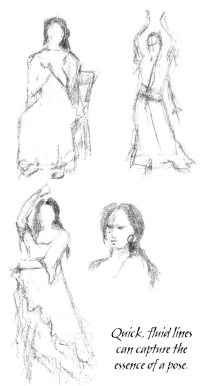

Quick, fluid lines
can capture the
essence of a pose.

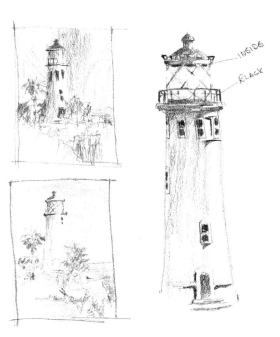

INSIDE

BLACK

Preliminary sketches can even indicate
some details and shading!

15

Assessing the Right Approach

When I set out to sketch, I always ask myself, "How much time do I have?" This is an important question for determining the size and scope of the project I can undertake. If I start out knowing my time is limited, I can work within those parameters to my satisfaction by keeping my expectations in check; for example, I don't anticipate I'll be able to complete a detailed watercolor in an abbreviated time period. Instead of trying to squeeze in something I don't have time for, which could leave me feeling rushed or frustrated, I'll approach my subject in one of the quick manners shown on these pages.

Sketching Loosely and Freely

Even when you have all the time in the world, you may have to work with a limited-time approach—especially when you're dealing with people and animals. You can try pleading with wild animals or total strangers all you want, but even when they're cooperative, you're not likely to keep them at a standstill for long. The trick to capturing these subjects is to sketch loosely and freely, using quick strokes to capture a fleeting pose.

I use pens to quickly record the basic shape of the subject. (Ink is easier to see in sunlight than pencil is.) Then, if the subject moves, I usually start another sketch alongside the first one. (This is especially true at the zoo—because animals tend to return to their favorite spots, I often have a chance to complete the first sketch at a later time.)

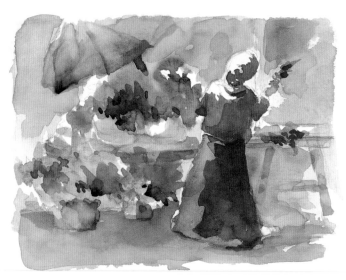

When you sketch people, be aware of their need for privacy; if someone doesn't like being sketched, stop. Better yet, ask for permission before you begin.

You'll find that many of us artists have a fondness for a location or subject matter, and we return to it again and again. The zoo is a great place for making quick studies—or more detailed sketches, when time allows.

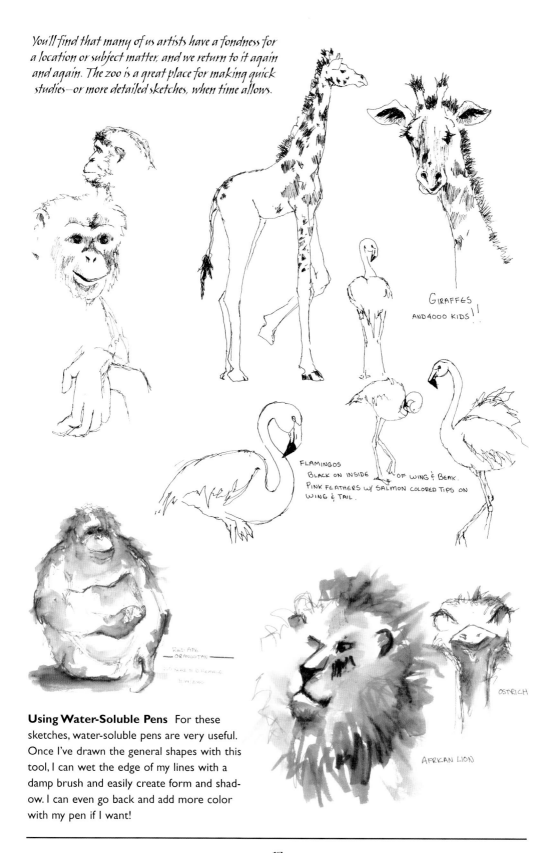

GIRAFFES
AND 4000 KIDS!!

FLAMINGOS
BLACK ON INSIDE OF WING & BEAK.
PINK FEATHERS W/ SALMON COLORED TIPS ON
WING & TAIL.

RE: APE
ORANGUTAN

OSTRICH

AFRICAN LION

Using Water-Soluble Pens For these sketches, water-soluble pens are very useful. Once I've drawn the general shapes with this tool, I can wet the edge of my lines with a damp brush and easily create form and shadow. I can even go back and add more color with my pen if I want!

Recording Details

Even when you don't have time to sketch an entire scene in detail, you can still record small, detailed studies of parts of the scene. Doing so can be just as rewarding as sketching quick impressions of the larger view. If I'm standing in a field of flowers, I can make a rough sketch of the entire landscape, detailed studies of individual plants, or both! In the same vein, if I'm sketching a building with beautiful architectural details, I might supplement a larger sketch with small detail studies. Approaching the same subject from different viewpoints can help you get a better sense of the scene as a whole—and it can be a refreshing change of pace!

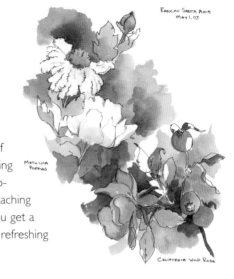

MATILIJA POPPIES

CALIFORNIA WILD ROSE

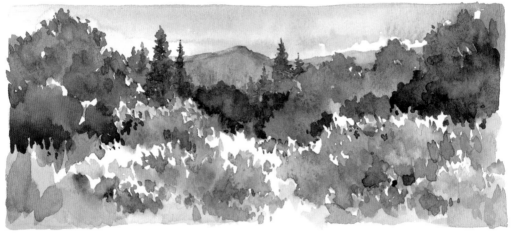

Working in Monochrome

Developing details takes time, as does mixing color. Sometimes when I really want to focus on the details of a scene, I forego color mixing and work in *monochrome*— just one color. Working with a monochromatic color scheme allows you to approach the subject in a very straightforward way. I typically draw with a colored water-soluble pen, pulling color from the line to lightly tint the paper. In the darker passages, I use the pen alone, without diluting the ink with water. You can also approach a monochromatic study by drawing the scene in pencil or pen and then tinting the paper with any one watercolor hue.

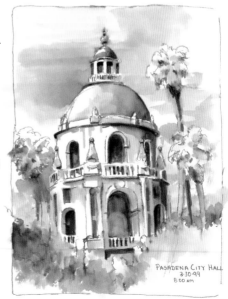

PASADENA CITY HALL
3-30-99
8:00 AM

Monochromatic sketches done in sepia or burnt sienna have an old-world feel, similar to that of a tinted photo from long ago.

Simplifying with Vignettes

The *vignette* is an open format that keeps information out of the corners and touches the border in only two or three spots. The uncomplicated design gives the sketch a somewhat unfinished appearance, allowing a more spontaneous approach. I typically limit myself to four colors when working in a vignette format—applying a simplified palette to a simplified format.

"My work is purely autobiographical. It is about myself and my surroundings."
—Lucian Freud

Deciding on a Composition

Composition and design are terms that send the faint of heart running for the door—but they don't have to be frightening! It's possible to start down the right path with a simple overview of the subject, without getting into intricacies. If you wish to do a more in-depth study of these topics, see *Composition* by James Horton, also in the Walter Foster Artist's Library Series.

Determining the Focus

Determining the subject of your painting is only the first step; the next is to design the composition. To do so, ask yourself, "What do I wish to say?" The answer to this question will establish the *center of interest*— or *focal point*—of the painting. Surprisingly many artists don't know what or where their center of interest is; and if they don't know, neither will the viewer!

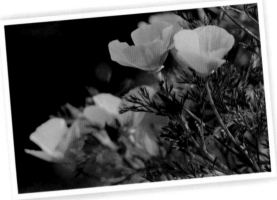

Once you've determined the focal point, you need to decide on its placement. You can always create a well-balanced composition if you follow the *rule of thirds,* also called the "intersection of thirds"; to follow this principle, divide the paper into thirds horizontally and vertically. Then place your center of interest at or near one of the points where the lines intersect. It's as simple as that! The rule of thirds keeps your center of interest away from the extremes—corners, dead center, or the very top or bottom of the composition—all recipes for design disaster. The result is a piece that holds the viewer's interest!

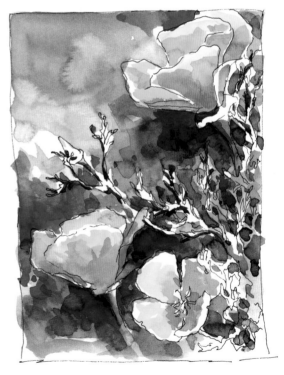

Approaching the Painting There were several ways I could have approached these lovely wildflowers; the rule of thirds helped me make a final design decision. Note that the area containing my focal point has the greatest amount of detail and contrast; it features the lightest lights and the darkest darks.

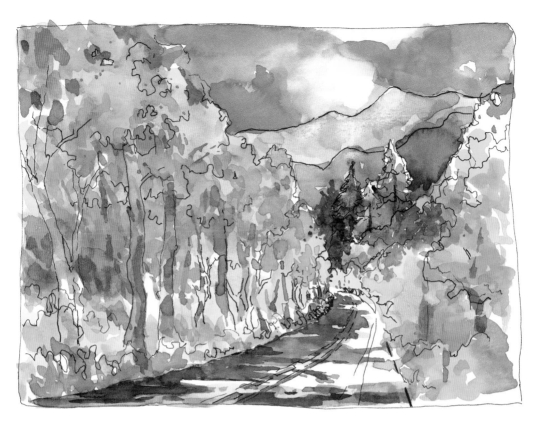

Testing Your Designs

Even when applying the rule of thirds, you'll usually find that you have a selection of designs to choose from. *Thumbnail sketches*—or small compositional studies—are the insurance policy of smart artists! They allow us to quickly work out a composition before committing time and effort to a sketch or painting. These sketches are small—2 to 3 inches at most—but they contain the necessary information about a scene's arrangements and values. It's always wise to make a few thumbnails before committing to a design.

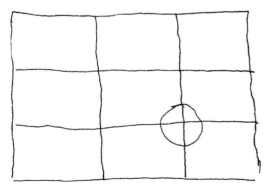

Finding the Best Format

Usually the subject itself determines the *format*—the shape, size, and orientation (horizontal or vertical)—I select. You can choose from a variety of formats, including square, rectangle (portrait or landscape), and panorama. In general, horizontal formats are ideal for broad stretches of land or sea, whereas vertical formats are the logical choice for tall subjects, such as a lone tree. I've found I make the best format choices when I sketch out the the elements of my composition first, before choosing the format.

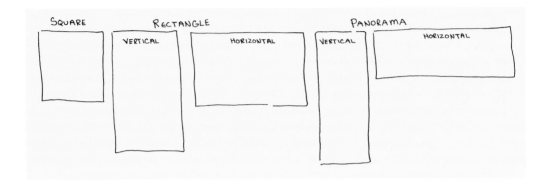

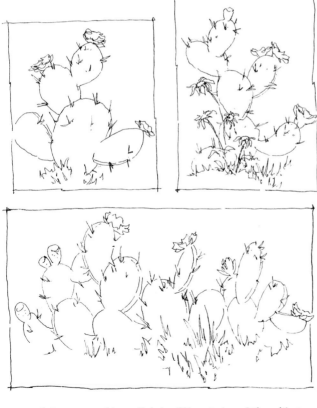

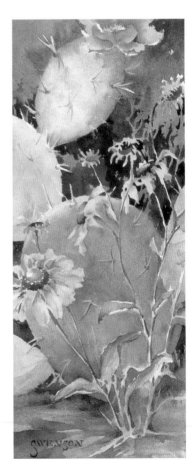

Each format provides a slightly different view of the subject.

22

View from Above
This viewpoint creates a
dramatic sense of space.

View from Eye Level
Eye level is the most
common viewpoint.

View from Below
Subjects viewed from this angle
can appear larger than life!

Choosing a Viewpoint

Although I paint many subjects at eye level, sometimes I like to paint a subject from above (bird's-eye view) or below (worm's-eye view). These distinct viewpoints can add a more dramatic feel to even the most ordinary subjects. To experiment with points of view, place your horizon either lower or higher on your page; then alter the angle—or perspective—accordingly, as shown in the examples here. You'll often find that artists use more exaggerated points of view when painting landscapes and city scenes, but still lifes and interiors can benefit from a slightly different perspective as well.

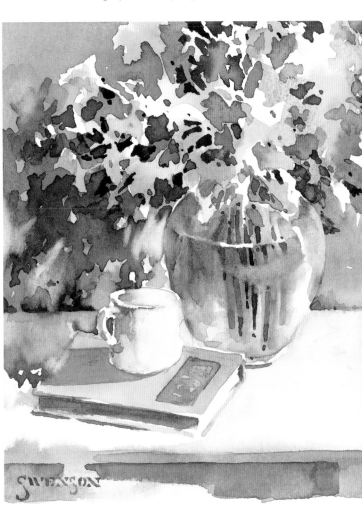

*For a creative change, I painted this still life from
a bird's-eye point of view, breathing new life into an
ordinary group of objects by looking at them in a new way!*

Rearranging Elements

Creating a strong composition sometimes requires a little imagination. So often we set out to record what we see in an exact, meticulous fashion—right down to every last building and tree. But one of the most exciting aspects of being an artist is having the ability to create what doesn't exist. What fun it is to be able to move mountains and buildings, rearrange the countryside, and change the weather with just a flick of the wrist!

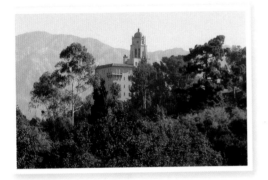 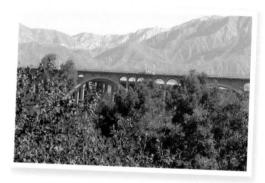

Taking In the Scenery On this particular day, my gaze fell upon trees, mountains, shrubbery, a building, and a bridge—all good painting elements. But the way they were physically laid out on the landscape wasn't visually appealing to me. So I decided to rearrange the objects and create my own composition!

Mapping Out the Elements of a Scene

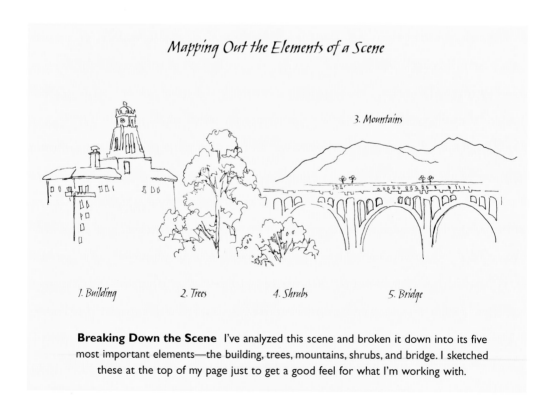

3. Mountains

1. Building 2. Trees 4. Shrubs 5. Bridge

Breaking Down the Scene I've analyzed this scene and broken it down into its five most important elements—the building, trees, mountains, shrubs, and bridge. I sketched these at the top of my page just to get a good feel for what I'm working with.

Choosing a Format

Once I've determined the elements, I start creating small thumbnails to determine their placement. I try out different kinds of formats—square, portrait, landscape, and panorama—and I don't always include every element in the rearranged scenes. It's a good rule of thumb to try at least four different arrangements, placing three to five elements in each. When you find one that works for you, paint!

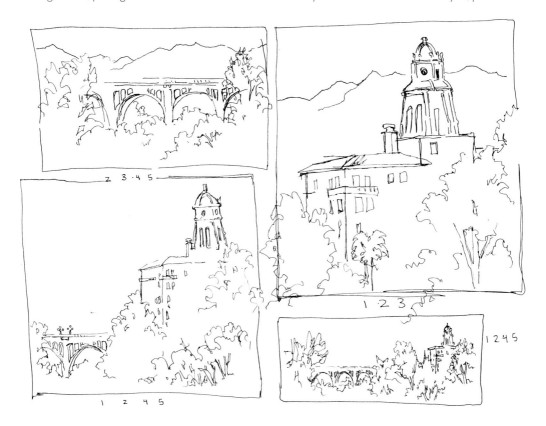

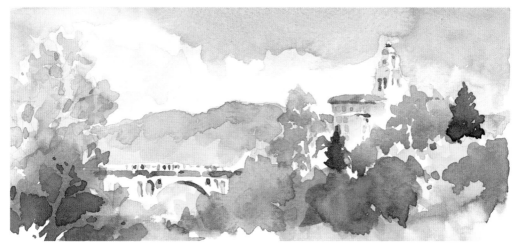

I chose the panorama because of its balance—the elements share equal prominence, yet the focal point is clear.

Increasing Color Awareness

Choosing color is an essential part of expressing any artistic vision; but, for the most part, color selection is a personal decision. Understanding the basics of color and color relationships will help you get the most out of your choices. And learning to observe value and color will also help you better understand and express what you see. To begin, it's helpful to become familiar with the way colors interact with one another. For example, colors directly across from each other on the wheel—called "complements"—create drama when paired together in a painting, but they produce dynamic, natural-looking neutrals when mixed.

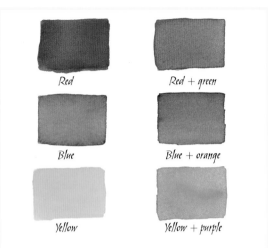

Red	Red + green
Blue	Blue + orange
Yellow	Yellow + purple

Mixing Neutrals You can "gray" or neutralize any color simply by mixing it with a small amount of its complementary color. Here the three primary colors are grayed by their complements.

Color Wheel Combinations

The easiest way to understand colors and their relationships to one another is to see them positioned on a color wheel. On a standard color wheel, each color is positioned directly across from its complement. On this color wheel, the inner portion of the wheel pairs each color with its complement, allowing you to see the drama each pairing will produce. The wheel also demonstrates the effect analogous colors can produce. analogous colors are groups of colors that are close to each other on the wheel, such as yellow-orange, orange, and red-orange. Looking at the wheel, we can see that colors closest together have the most harmony. It's a smart idea to paint your own color wheel using your personal color palette; this will allow you to see how the colors you've chosen will interact with one another.

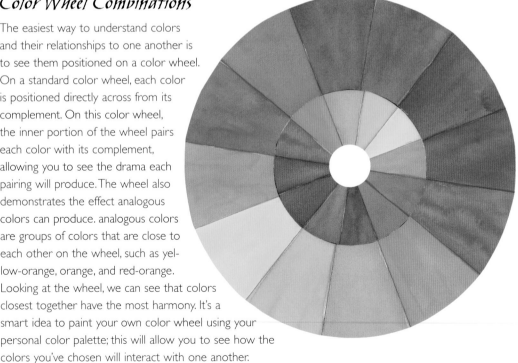

Observing Values

It's the contrasts between light and dark values that make watercolor sketches sparkle! Differentiation among values is easy to see in black and white (see page 10), but values are harder to distinguish in color. If you need help seeing the difference between values, try squinting your eyes; this makes the color become less central, allowing you to pick out values more easily.

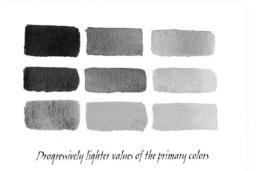

Progressively lighter values of the primary colors

The Effect of Light

When sketching a scene with a bright light source—such as when painting outdoors in bright daylight—whatever object is facing the light appears almost white. This portion of the painting contains the lightest hues and values. Directly opposite, you'll find the darkest shadows—and thus the darkest hues and values. Some hues, such as yellows, will never have truly dark values. To emphasize those hues or to make them appear darker, I place a dark value of another color next to them.

The color complements in this sketch immediately catch the eye. But it's the varied values that establish the light source. And a multitude of green hues create harmony and interest!

Exploring Time of Day

The sun's ever-changing position in the sky influences the way colors and shadows appear to us at different times of day. For example, during the morning hours, we perceive softer colors with long shadows. At mid-day, when the sun is overhead, colors appear brighter but washed out, while shadows are minimized. And in the late afternoon, colors seem warmer and shadows are again lengthened.

Variations in shadows and colors give the same subject a different appearance at the day's start, middle, and end.

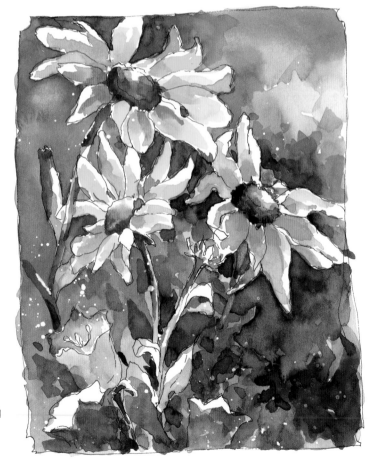

Building Drama
In the late afternoon, both the subject and the elongated shadows display intriguing warm variations.

Expressing Mood with Color

Choosing colors isn't just a matter of replicating what you see; colors possess an emotional quality that should also be taken into account. For example, warm colors (yellows, oranges, and reds) emit life, energy, and strength; whereas cool colors (greens, blues, and purples) evoke quietude, tranquility, and serenity. You can use the inherent emotional aspects of colors to your benefit by exercising "temperature dominance." Before you begin painting, first determine whether the mood you want to express is warm or cool; then let that choice guide your color selection.

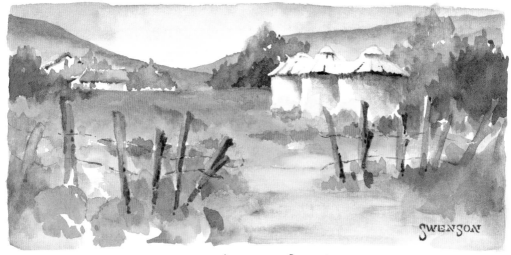

LANCASTER, ON THE
· ROAD TO CALIFORNIA POPPY PRESERVE ·
MAY 21, 2003

Warm Colors Warm colors produce a sense of excitement and summer heat. With temperature dominance in mind, even "cool" greens are mixed with warm yellow influences.

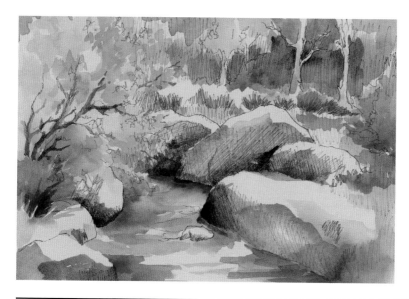

◀ Cool Colors
Warm touches keep this predominantly cool scene from appearing too tranquil.

"Color gets all the glory, but value does all the work."
—Anonymous

Sketching Indoors

Although basic sketching techniques and methods apply both indoors and outdoors, each type of location has its own special conditions that will affect how you approach your sketches.

Manipulating Your Subject

When working outdoors from life, you can rearrange buildings and landmarks in your head or on paper; but working from life in the studio allows you to actually manipulate the position of your subject and the arrangement of your composition. Physically rearranging compositions in the studio will also strengthen your spatial skills, making it easier to mentally rearrange things when outdoors.

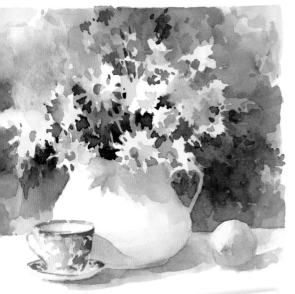

Lighting the Subject

Another benefit to working indoors is lighting control. Artificial lighting lets you work at night or on rainy days. And with artificial light, you can manipulate the direction and strength of the light source for interesting shadows. You may want to use natural light—such as light from a window—when indoors; but natural light can interfere with artificial light, so it's best to use only one.

Working from Photos

Taking your own photos allows you to capture scenes when you're short on time, and it also helps you learn how to frame images. If a scene catches my eye, I take several shots of it from different angles. Then I take that information back to the studio. But I seldom copy photos exactly; instead I use them as references or guides that provide basic information and a jumping-off point for my creativity.

I like to keep artificial flowers, vases, fruit, and other items in my studio. Even when seasons change, I still have props to stimulate my creativity!

I keep my camera readily available because I never know when an opportunity might present itself. For example, driving through the Arizona desert, I came across a man and his covered wagon. He was alone, except for his dog and three donkeys. I wouldn't have been comfortable asking the man to stand still so that I could sketch him, but I did ask permission to take his picture. I was delighted to have the photographs to work from at home. But the final sketch isn't just a product of the photo—it also showcases my memory and creativity.

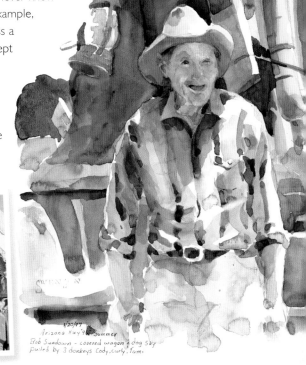

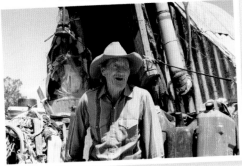

On another trip, I started a pen sketch of a row of houses. The day was bright and sunny when I began, but the sky quickly turned gray, leaving me uninspired to finish my sketch. I took a reference photo and moved on. Unfortunately the resulting photo held none of the initial charm I felt for the location. The important thing to remember when using photo references is this: A camera has one eye and no brain. Don't rely on the camera to put life into your work—that's your job as an artist. You have the freedom to make any changes you like! Even when working from photos, you can use your *artistic license* to alter your sketch in ways that capture the essence of your subject, whether that means rearranging items, changing colors, or omitting unnecessary elements.

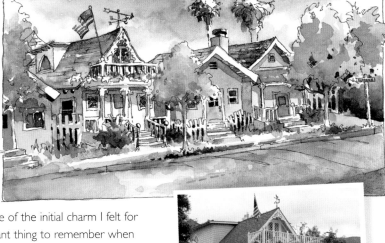

Be aware: Photos tend to flatten and distort an image. Shadows lack color and appear darker than they do in life.

Sketching on Location

One of the great advantages of keeping a sketchbook is that it's small enough to go with you anywhere—I've sketched everywhere imaginable, from outdoor flower markets to historical buildings! No matter where you are or what you're surrounded by, you have before you a wonderful opportunity to sketch. Don't feel as if you have to wait for the perfect image to begin recording.

Outdoor sketching requires a different kind of preparation than indoor sketching does. For example, you need to pay attention to the time of day and the wea-ther to be sure you'll have plenty of natural light available. When I plan to sketch outdoors, I like to be on location between 8:30 and 11:30 in the morning. (For more about time of day, see page 28.)

When I arrive, the first thing I do is walk around for at least 10 minutes to get a sense of the location. Until I take a look around, I don't know what options are available! When I find something that captures my interest, I take notice of how the sun's position will change the scene over the period I'll be painting. If the focal point of my intended subject will be shrouded in shadow shortly, it won't make a good choice.

When I begin sketching, the sun's movement is still a huge factor. I frequently take written notes or make pencil marks on my sketch to record the placement of shadows before they change. If you're planning to turn the sketch into a full painting later, it's also a good idea to record information about the time of day, weather conditions, people you meet, and so on—anything that will help you remember!

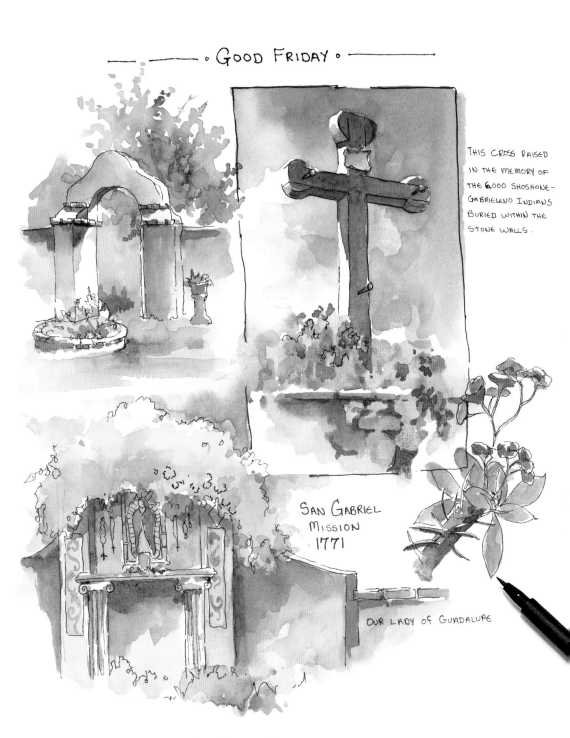

THIS CROSS RAISED IN THE MEMORY OF THE 6,000 SHOSHONE-GABRIELENO INDIANS BURIED WITHIN THE STONE WALLS.

SAN GABRIEL MISSION 1771

OUR LADY OF GUADALUPE

Sometimes I find several scenes I'd like to sketch all at one location. When this happens, I like to create a visual collage of multiple images on one page of my sketchbook.

Watching Out for Personal Safety

It's very important to be aware of your surroundings when painting outdoors, and not just to get a good feel for the subject. The most important reason to be aware of your environment is for your own personal safety. This should always be your first priority. Because artists tend to become engulfed in their work, it's never a good idea to work alone. We become oblivious to traffic, loose dogs, and everything else! Having an extra body (and an extra set of eyes) is a smart procedure—and it's always fun to have a painting partner with you to share your experience.

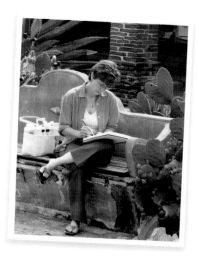

Busy locations with a lot of people offer great opportunities for sketching—but these colorful and active surroundings require you to be alert and attentive. Always be sure to put your personal safety first!

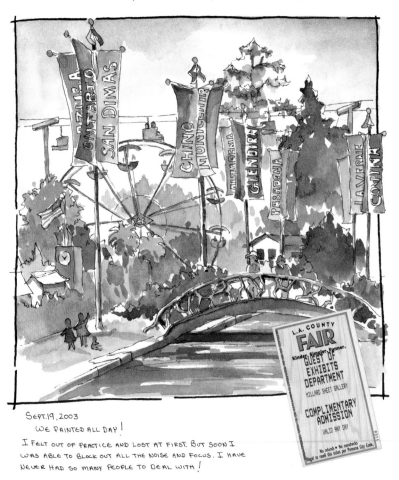

SEPT. 19, 2003
 WE PAINTED ALL DAY!

I FELT OUT OF PRACTICE AND LOST AT FIRST. BUT SOON I WAS ABLE TO BLOCK OUT ALL THE NOISE AND FOCUS. I HAVE NEVER HAD SO MANY PEOPLE TO DEAL WITH!

Coping with the Sun

When you're involved in your work, it's easy to lose track of time. But it's very important to pay attention to the sun's strength and location. Even when wearing sunblock, it's smart to sit in the shade, as this will shield your eyes. When the light reflects directly off your paper and into your eyes, you risk burning your corneas. Repeated exposure to the sun in this manner can lead to serious eye problems.

Dealing with Onlookers

I've found that curious onlookers are almost always a part of working on location. In general, people are friendly and don't hang around too long. If they wear out their welcome, though, I very nicely close my sketchbook to let them know show-and-tell time is over.

If you really want to discourage onlookers, place a hat at your feet and put a dollar bill inside—no one will come within 10 feet of you!

Preparing Supplies for Outdoor Painting

When painting outdoors, I use the same basic sketching materials as I do indoors—the difference is that I use travel palettes outdoors (as shown) and keep my supplies to a minimum. While working on location, it's important to keep your supplies lightweight and compact. Not only do you want to save your back, but you want to be mobile enough to adapt to any location. Aside from my sun hat and folding stool, everything I bring fits nicely into a small canvas bag.

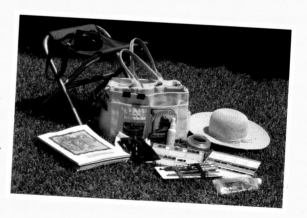

Recording Your Travel Memories

Have you ever traveled and taken dozens upon dozens of photos, only to be disappointed with the results? Even when the quality of a photograph is high, a picture alone rarely expresses your emotional and physical response to the subject of the photograph. I take photos when I travel, but I also like to bring my sketchbook with me to record memories. And the watercolor sketch doesn't stand alone in my sketchbook journal; it's accompanied by notes about my experience and little mementos I've gathered along my journey. Often my notes cover things that you may not be seeing in the sketch, such as the scents in the air, the temperature of the day, the sounds of birds or the traffic, and more. For me, something magical happens when I integrate written words with a visual scene; the image becomes forever locked in my memory. And when I go over my written notes, I engage my other senses, recalling that very moment in time. A photograph, no matter how great it is, can never do all that! A camera records the image, but a sketchbook artist records the memory.

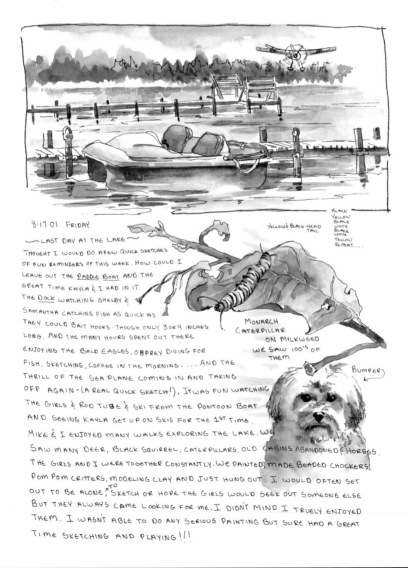

8·17·01 FRIDAY

—LAST DAY AT THE LAKE—
THOUGHT I WOULD DO A FEW QUICK SKETCHES
OF FUN REMINDERS OF THIS WEEK. HOW COULD I
LEAVE OUT THE PADDLE BOAT AND THE
GREAT TIME KAYLA & I HAD IN IT.
THE DOCK WATCHING SHELBY &
SAMANTHA CATCHING FISH AS QUICK AS
THEY COULD BAIT HOOKS - THOUGH ONLY 3 OR 4 INCHES
LONG. AND THE MANY HOURS SPENT OUT THERE
ENJOYING THE BALD EAGLES, OSPREY DIVING FOR
FISH, SKETCHING, COFFEE IN THE MORNING.... AND THE
THRILL OF THE SEA PLANE COMING IN AND TAKING
OFF AGAIN - (A REAL QUICK SKETCH!). IT WAS FUN WATCHING
THE GIRLS & ROD TUBE & SKI FROM THE PONTOON BOAT
AND SEEING KAYLA GET UP ON SKIS FOR THE 1ST TIME.
MIKE & I ENJOYED MANY WALKS EXPLORING THE LAKE. WE
SAW MANY DEER, BLACK SQUIRREL, CATERPILLARS, OLD CABINS ABANDONED & HORSES.
THE GIRLS AND I WERE TOGETHER CONSTANTLY. WE PAINTED, MADE BEADED CHOCKERS,
POM POM CRITTERS, MODELING CLAY AND JUST HUNG OUT. I WOULD OFTEN SET
OUT TO BE ALONE, TO SKETCH OR HOPE THE GIRLS WOULD SEEK OUT SOMEONE ELSE
BUT THEY ALWAYS CAME LOOKING FOR ME. I DIDN'T MIND I TRUELY ENJOYED
THEM. I WASN'T ABLE TO DO ANY SERIOUS PAINTING BUT SURE HAD A GREAT
TIME SKETCHING AND PLAYING !!!

YELLOW & BLACK-HEAD
TAIL

BLACK
YELLOW
BLACK
WHITE
BLACK
WHITE
YELLOW
REPEAT....

MONARCH
CATERPILLAR
ON MILKWEED
WE SAW 100'S OF
THEM

BUMPER

Anacapa Island

—— · Coreopsis & Seagulls · ——

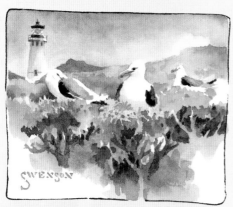
SWENSON

THE ISLAND IS FULL OF SPRING COLORS! COREOPSIS IS A BRIGHT YELLOW FLOWER WITH FOILAGE THAT ALMOST APPEARS LIKE PINE NEEDLES. THE MANY SEAGULLS ARE HEALTHY LOOKING. THEY SIT UPON THE TOPS OF THE COREOPSIS LIKE A NEST.

TIME WAS SHORT AND MY PENCIL SKETCHES ARE QUICK.

I HAD JUST ENOUGH TIME TO SKETCH AND HIKE AROUND BEFORE IT WAS TIME TO RETURN TO THE BOAT.

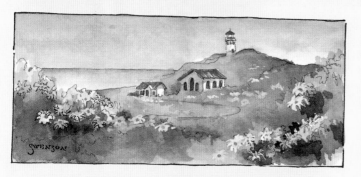
SWENSON

ON THE BOAT TRIP BACK WE SAW HUNDREDS OF DOLPHINS!

Capturing the Spirit of Your Trip

On a recent boat trip to Anacapa—one of the Channel Islands located just west of Los Angeles—I had only three hours to explore. Packing a few minimal supplies—a 6" x 9" sketchbook, pen, pencil, brush, and small folding palette—I was able to quickly sketch and write just enough to help me recall the experience. When I got home, I finished the sketches, pasted them into my larger sketchbook, and added my hand-written notes.

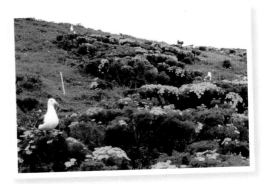

I'm so glad that I didn't rely solely on my camera. As you can see from these examples, my photos didn't capture the moment and the memories as well as my sketches did.

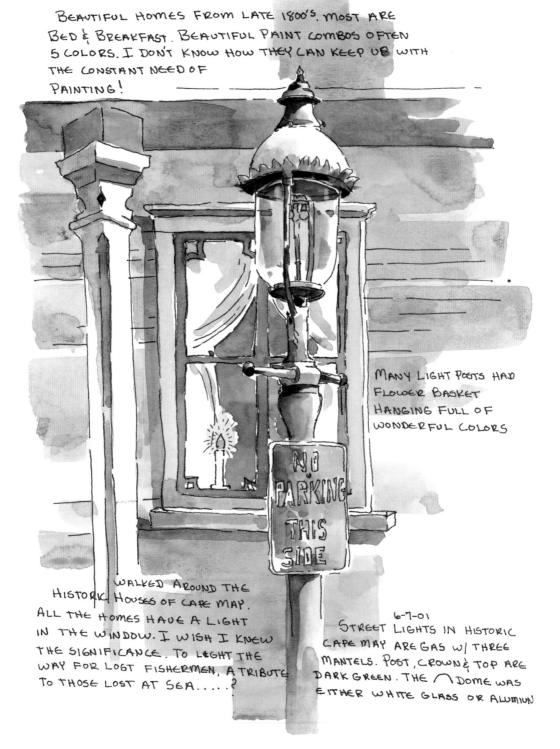

BEAUTIFUL HOMES FROM LATE 1800'S. MOST ARE
BED & BREAKFAST. BEAUTIFUL PAINT COMBOS OFTEN
5 COLORS. I DON'T KNOW HOW THEY CAN KEEP UP WITH
THE CONSTANT NEED OF
PAINTING!

MANY LIGHT POSTS HAD
FLOWER BASKET
HANGING FULL OF
WONDERFUL COLORS

NO
PARKING
THIS
SIDE

WALKED AROUND THE
HISTORIC HOUSES OF CAPE MAY.
ALL THE HOMES HAVE A LIGHT
IN THE WINDOW. I WISH I KNEW
THE SIGNIFICANCE. TO LIGHT THE
WAY FOR LOST FISHERMEN, A TRIBUTE
TO THOSE LOST AT SEA.....?

6-7-01
STREET LIGHTS IN HISTORIC
CAPE MAY ARE GAS W/ THREE
MANTELS. POST, CROWN & TOP ARE
DARK GREEN. THE ⌂ DOME WAS
EITHER WHITE GLASS OR ALUMIUN

"Painting is just another way of keeping a diary." – Pablo Picasso

Journaling About Everyday Life

Everyday events are what make up our lives. No matter how small and insignificant they may seem, don't automatically dismiss them as being unworthy subjects for sketching. You'll be surprised how fond you'll become of looking back over little sketches that seem in some small way to freeze moments in time forever in your memory.

My everyday journals are more private than my travel journals are; these collections of sketches and notes offer little glimpses into my personal life. Countless pages are light and humorous, yet others express sorrow or loss through images and words. Whether you share your sketchbook journal with others or use it to record your private moments is your choice—I have many pages I've never shared.

I DON'T KNOW OF A LITTLE CREATURE WITH MORE HEART THAN YOU.
YOU WERE NOTHING MORE THAN A LITTLE FLEA COVERED KITTEN WHEN MIKE
PULLED YOU OUT FROM UNDER A HOUSE, ALMOST 17 YEARS AGO. I THINK

YOU KNEW WE SAVED YOU.
BUTTERSCOTCH WAS HAPPY IN HER LITTLE WORLD AND NEVER WANTED TO GO OUT SIDE. SHE LOVED LAYING IN HOT FRESH LAUNDRY, CHEWING ON SHOE LACES, WASHING HER FACE WITH MY PJ'S (AFTER SHE HAD THEM WET!). SHE FETCHED UNTIL HER BODY GREW WEAK AND MEMORY SHORT. THERE ARE TIMES WHEN I KNOW SHE SMILED! YOU HAD SOME FUNNY HIDING PLACES UNDER THE SINK AND ONCE IN THE CHIMNEY. YOU WOULD GET FEISTY IF THE OTHER CATS GOT TO MIKE'S WORK SHIRT FIRST OR IF THEY DIDN'T SHARE THE SUNNY SPOT ON THE CARPET. I MISS SHARING OUR MORNING COFFEE ON THE CARPET WHILE YOU WASHED YOUR FACE.

BUTTERSCOTCH
SEPT. 1987 - AUG. 17, 2004

Exploring Light and Shadow

Watercolorists are drawn to light, and the white of the paper is our treasure! When assessing a subject or scene, the first thing I look for is the presence of light. Light can determine whether a subject is worth tackling or not, so I want to be very conscious of how it affects what I am looking at. After all, light is responsible for revealing color, texture, and form. And light can change a mundane scene into something exciting and full of energy!

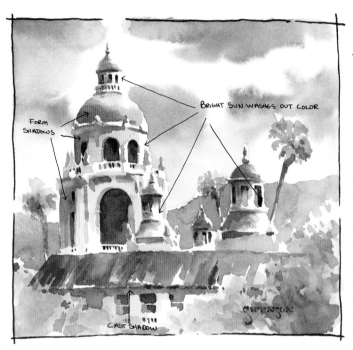

FORM SHADOWS

BRIGHT SUN WASHES OUT COLOR

CAST SHADOW

SWENSON

Understanding Shadows

Objects appear three-dimensional because they possess a range of light, dark, and medium values—their highlights, shadows, and local color. The placement of these values all depends on the light source—the light's angle, distance, and intensity will affect both the shadows on an object (called "form shadows") and the shadows the object throws onto other surfaces (called "cast shadows"). For example, form and cast shadows will always be on the sides of the object opposite the light source. Intense light will produce darker cast shadows. And the lower the light source, the longer cast shadows will become.

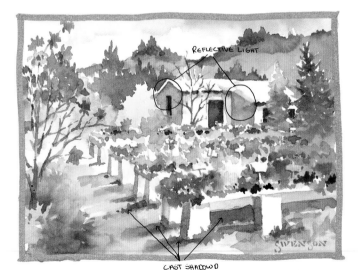

REFLECTIVE LIGHT

CAST SHADOWD

SWENSON

Shadows are really quite colorful! They hold darker values of the object's local color, with warmer tones in direct sunlight and cooler tones away from the light. And shadows also display colors reflected from nearby objects!

Although form shadows are responsible for giving an object a sense of dimension, cast shadows anchor or ground the object in space—providing visual interest and linking objects in a scene together. Cast shadows differ from form shadows in a few important ways: (1) cast shadows are darker than form shadows; (2) they share the same hue as the surfaces they fall upon, not the objects that cast them; (3) these shadows suggest the shape of the objects that cast them; and (4) cast shadows' edges are harder than those of form shadows.

Experimenting with Shadows

To better understand shadow and light, it helps to see the effect in person. I encourage you to try this experiment: On a sunny day, in the morning or late afternoon, set a box and a round object outside. Then place different colored papers next to each object to see the changes in shadows for yourself. You'll be able to compare and contrast the way the form shadows soften as they turn toward the light, whereas the cast shadows retain their distinct edges. And you'll notice several other things too; for instance, shadowed parts of an object are about 40 percent darker than highlighted parts are. And only a portion of the shadow reveals reflected color!

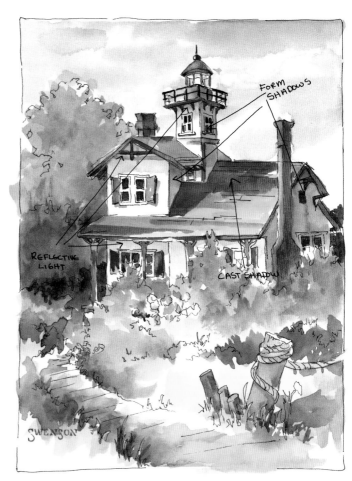

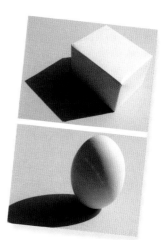

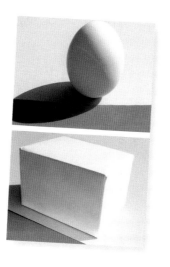

Changes in value are easier to see in black and white. If you have trouble distinguishing values, photocopying your reference photos might help!

Sketching with Light and Shadow

Sometimes you'll discover an interesting scene with light and shadow patterns that do very little to add interest or movement to the subject. But as the day advances and the light changes, the scene can transform in front of your eyes. When looking for subjects to paint, try to imagine how a subject will appear at different times of day. If you use your creative insight and have a little patience, you'll be able to harness the effects of light and shadow to direct the viewer's eye in and around your painting, finally leading the eye to the center of interest.

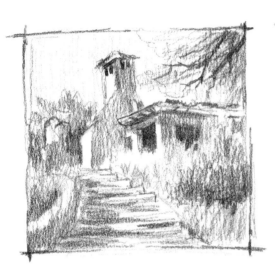

Late Afternoon I was interested in the architecture of this subject, but the light wasn't flattering.

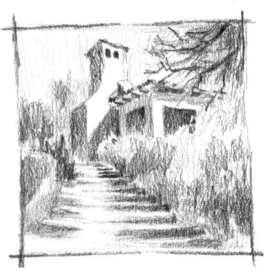

Late Morning At a different time of day, the same subject appears to come to life!

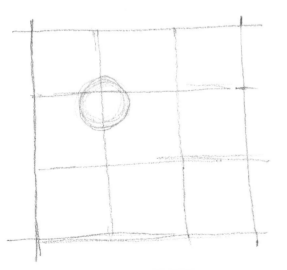

Center of Interest The rule of thirds once again successfully guides the placement of my center of interest!

Light Passage The cast shadow on the tower directs the eye downward, whereas the light and shadow pattern on the stairs brings the eye up.

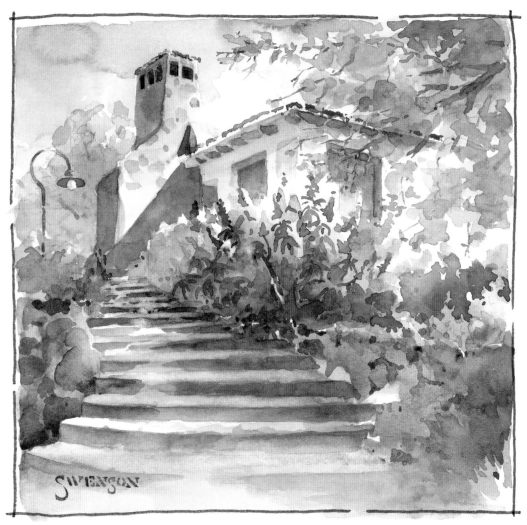

La Casita Del Arroyo in Pasadena, California

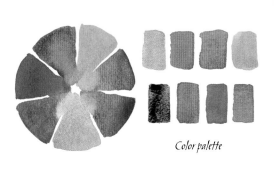

Color palette

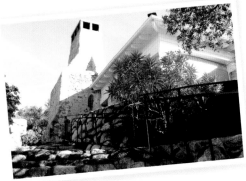

Photo reference

I like to make small color swatches while I'm on location—they're a more reliable reference than a photograph alone. Plus it's always good practice to try to mix and match the colors you see in nature!

Focusing on Perspective

Perspective is the representation of three-dimensional space on a two-dimensional surface. It's responsible for creating the illusion of depth and distance. Many artists try to make perspective into something more difficult than it is. The truth is, you've already seen perspective in action—you just didn't know what to call it. The rules of perspective simply explain the reasons behind what you're seeing.

Understanding Linear Perspective

Linear perspective is the most commonly recognized form of perspective. According to its rules, objects appear smaller as they recede into the distance. When learning about linear perspective, the *horizon line*—a horizontal line that bisects any given scene—is an important concept. It can be the actual horizon, or it can be a line that falls at eye level—meaning at the height of your eyes, not where your eyes are looking. The *vanishing point* (VP)—or the spot at which all parallel lines in a scene seem to converge—is always located on the horizon line.

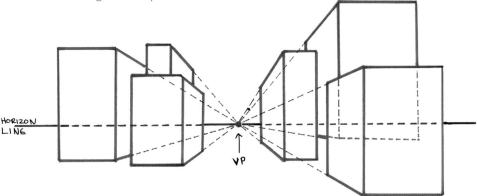

One-Point Perspective Objects appear to shrink proportionately to one another as they recede into space. When applying *one-point linear perspective*, all the horizontal lines converge at one vanishing point in the distance. The vertical lines all remain at the same 90° angle.

One-Point Perspective

When lines are all on one plane—such as with railroad tracks—the receding lines converge at one vanishing point. Think again of the railroad tracks—parallel stripes receding into the distance, with the space between them growing smaller until the lines merge on the horizon. Establishing the vanishing point will help you determine the correct angle for any lines coming toward (or moving away from) the viewer; but the angle of vertical or horizontal lines won't be affected. (See diagram above.)

A road is one of the simplest ways to demonstrate one-point perspective at work—the lines converge at a distant point.

Two-Point Perspective

If a scene has more than one plane—for instance, if you are looking at the corner of an object rather than the flat face of it—then you should follow the rules of *two-point perspective*. With two-point perspective, there are two vanishing points. To find the vanishing points, first find your horizon line. Next

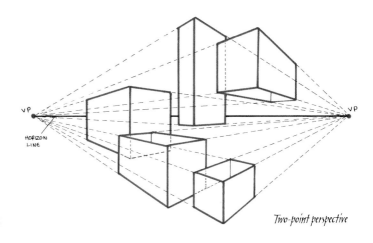

Two-point perspective

draw a line that follow one of the object's angled horizontal lines, extending the line until it meets the horizon line. This establishes one vanishing point. Now repeat this process for the opposite side of the object to establish the remaining vanishing point. (Note: Sometimes a line will extend to a vanishing point that isn't contained on the page!) Each vanishing point applies to the angle of all parallel planes that are receding in the same direction. As with one-point perspective, vertical lines will all remain at the same 90° angle—only their size (in terms of length) will be affected by perspective.

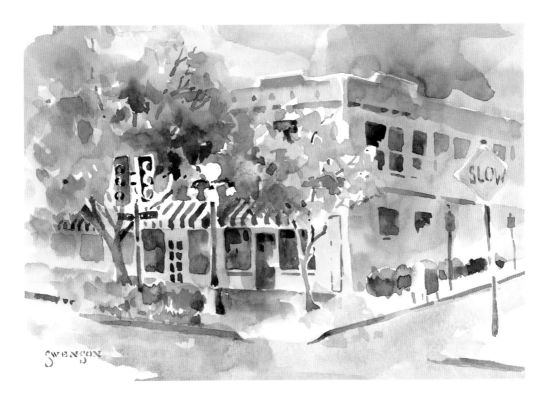

True creativity is taking what you know and making it more than it was!

45

Sketching with Linear Perspective

This clock is an important landmark in the center of our town. I wanted it to be a dominant part of the sketch and be nearly as tall as the page. One of the problems I faced was how to place the clock in the immediate foreground and not end up with a large amount of distortion. After doing a couple of sketches from different heights, I determined that the lower the horizon line (and thus the farther away the top of the clock is from the horizon), the more severe the distortion. For moderate angles, I placed the horizon line more toward the center of the page.

Clock of South Pasadena, California

Testing Angles with Thumbnail Sketches

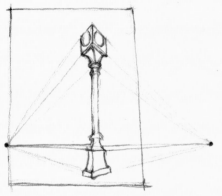

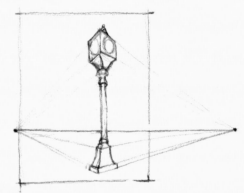

High Distortion When viewed from the ground, the horizon line appeared low and the distortion of the clock was strong.

Medium Distortion When I moved to a folding chair, the horizon line adjusted upward, but there was still some distortion.

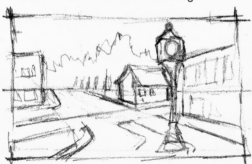

Low Distortion When I stood to sketch the clock, the horizon line appeared higher—closer to the top of the clock. This angle of perspective pleased me—but the horizontal format did not.

Testing the Angle I applied some shading to a thumbnail of the scene to test out my chosen format and angle of perspective—and I was pleased enough with the results to go forward with the sketch!

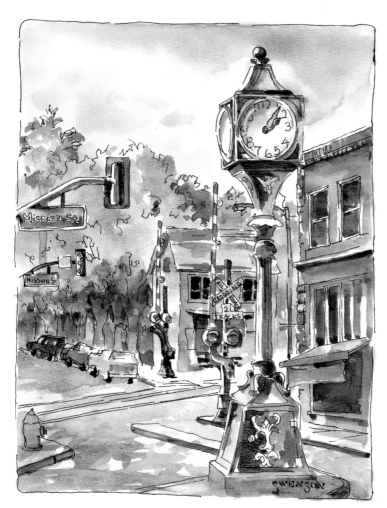

Applying the principles of perspective to your subjects will help you achieve realistic-looking sketches, but you don't have to follow the rules rigidly. When drawings are too tight or stiff, they lose their human quality; if you bind yourself to exact lines and angles, you might turn your lively street scene into an architectural drawing. Feel free to apply your artistic interpretation to a scene to create a more natural look. Think of it this way: You can be irritatingly correct or charmingly incorrect!

You don't have to get bogged down with perspective, spending hours working out angles when all you really want to do is paint! When I'm sketching on location and I'm struggling with the angle of a detail, I simply hold out my pencil at arm's length, line it up with the angle I see, and then bring the pencil down to my paper and record the same angle. This may sound like a cheap trick, but it's a quick fix that really works!

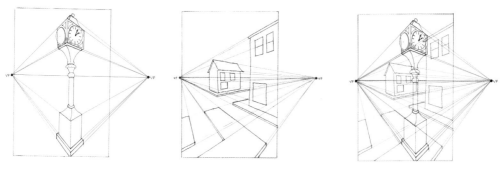

Simplifying Perspective Don't allow perspective to overwhelm you. It may help to check your angles separately, starting with the clock, then adding the road and buildings for a complete scene.

Creating Space and Distance

Linear perspective is critical to creating the illusion of depth and dimension in your sketches, but so is *atmospheric perspective*. Atmospheric (sometimes called "aerial") perspective is responsible for the way objects in our field of vision appear to change in size, color, texture, focus, and even brightness as they recede into the distance. Outside, impurities in the air (such as moisture and dust) block out some sunlight, so objects in the distance appear less distinct and with softer edges than do objects in the foreground. And because the longer, red wavelengths of light are filtered out, things in the distance also appear cooler and bluer. Reproducing these atmospheric effects in our artwork helps us develop a sense of space and distance.

Adding Dimension to Your Sketches

To create the illusion of depth in your sketches with atmospheric perspective, there are a few things you should keep in mind about the size of the elements of your sketch, as well as their position, clarity, and color. Larger objects appear closer, whereas smaller objects seem to be distant. Over-lapping objects, one in front of another, can make them appear as if they are on different planes within a scene. Details are most pronounced in nearer objects; things become more and more out of focus the farther away they are. And color intensity is much stronger in the foreground of the painting; as you move into the middle ground and then into the background, colors appear gradually more grayed.

◀ **Distinguishing the Planes** The foreground shrubs boast the most vibrant foliage color and detail in this scene. In the middle ground, the trees have a softer, more out-of-focus look. And the trees in the distant background are grayed and indistinct.

▶ **Pairing Perspectives** Linear perspective is responsible for the way the path narrows as it leads into the distance. But atmospheric perspective accounts for the blurring of forms and dulling of colors in the distance.

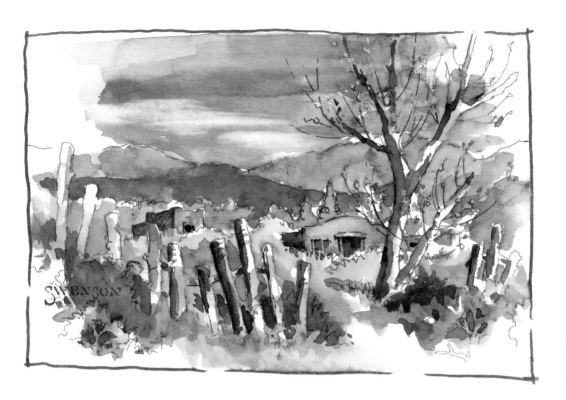

▲ Sizing and Overlapping Elements
The house pictured here would be taller than the fence if the two elements were placed side by side—but enlarging the posts makes them appear nearer. Similarly, overlapping the house with the tree pushes the house into the distance, creating a more realistic sense of depth.

▶ Implementing Color Distinctions The contrast between the bright warm flower shapes in the foreground and the hazy, gray trees of the background help explain why Leonardo da Vinci called atmospheric perspective "the perspective of disappearance!"

Sketching with Atmospheric Perspective

It's a challenge to achieve a sense of space and distance when there aren't any foreground or background elements in a scene. For example, I loved the symmetry and simplicity of the windmills I saw while vacationing in the Netherlands. But I didn't think the scene had much depth or interest to it until I added a tulip field. Applying atmospheric perspective, I made the flowers—which are large, bright, and detailed in the closest area of the foreground—smaller, less vibrant, and less detailed toward the horizon, where they merge into a cluster of color. The windmill is relatively small compared to the tulips; and both its size and the overlapping flowers help push it back in space, as does its grayed color.

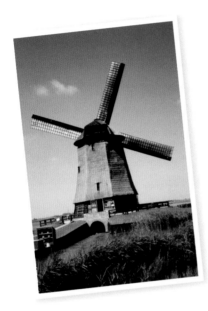

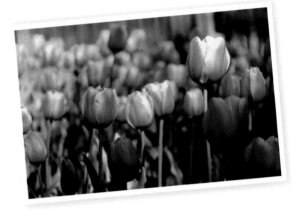

When I traveled to the Netherlands, I saw a lot of wonderful places and things—but no tulips! At home, I combined references to create what I might have seen if I'd visited in another season!

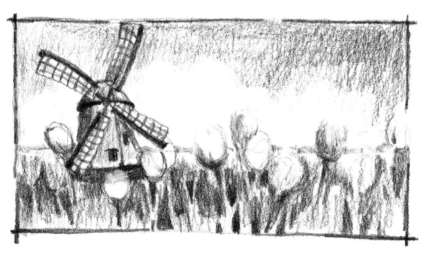

Arranging the Composition Adding the tulips to this scene helps emphasize the depth of the composition. The flowers loom large in the foreground, and their detail and size contrast with the windmill, which they overlap.

◄ **Static Composition** This arrangement feels dull. The windmill takes up too much space and there isn't a feeling of distance.

◄ **Dynamic Composition** I re-worked the composition in a vertical format to really emphasize the size and detail contrasts. I like this study because it has a strong sense of foreground, middle ground, and background.

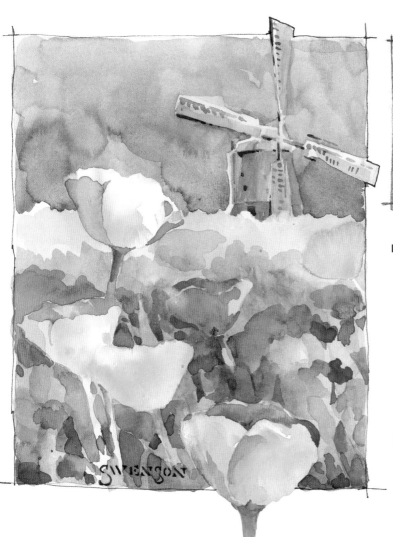

Leading the Eye
I used the tulips to create a clear path for the eye to follow, leading from the bottom of the page into the middle ground and up to the windmill.

"Creativity takes courage."
—Henri Matisse

Painting White Objects

When working with watercolor, what you *don't* paint can be just as important as what you do! As watercolorists, one of our most intriguing challenges is deciding when and where to forego painting and leave the white of the paper as the "color." Whereas oil painters add their white highlights last, we must determine our whites from the very beginning!

Beginning with a Value Study

I find it very helpful to complete a value study when I'm concerned with "saving" whites. The value study helps me plan my painting, providing a road map for the placement of everything from my lightest highlights—the white of the paper—to my darkest darks. I'll build up my color from light to dark according to this plan, painting around the all-important white parts I've designated in my guide.

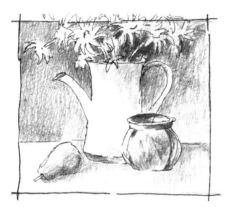 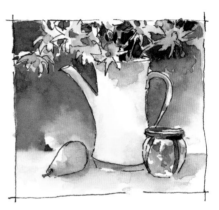

Distinguishing Values The parts of my thumbnail value sketch without color represent my highlights. Some parts of these areas will be pure white—but others may also include light-valued colors.

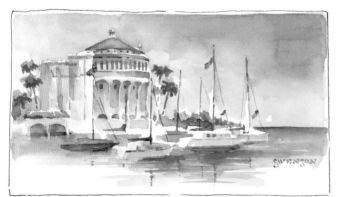

Seeing Reflective Colors in Whites

Very few things are ever "pure white" in a sketch. When painting a white subject, I typically reserve the white of the paper for the brightest highlights—usually the parts or points of the object that are in direct light. The rest of the white object contains hints of other colors. The highlights, midtones, and shadows of a white object will all contain hints of local color reflected off neighboring objects!

Working with Negative Space

Sometimes it's easier to define an object by painting the area *around* it instead of the object itself. The object is considered *positive space*, so its surroundings are called "negative space." By painting the negative shapes around an object, you're also creating the edges of the object at the same time!

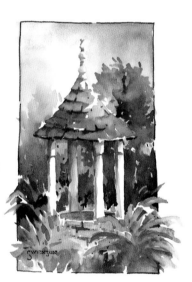

Negative and positive spaces are equally important in a design.

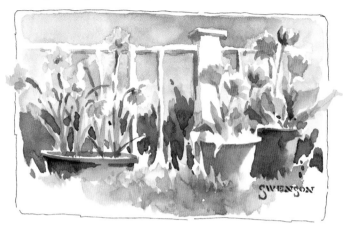

• DESCANSO GARDENS •
EVERY THING IS IN BLOOM!

Think of negative space as a positive approach!

GINNY & I CAME TO PAINT AND FOUND THE GARDENS ALL FULL OF TULIPS AND BLOOSMS. THE BIG FLOWER SHOW OPENS IN 2 DAYS. IT HAS BEEN SO VERY HOT I HOPE THE FLOWERS HOLD UP.

3·18·04

DESCANSO GARDENS GUILD
1418 DESCANSO DRIVE
LA CANADA FLINTRIDGE, CA
BEAUTIFUL
EVERY MONTH OF THE YEAR

03-19-2004 THU #6

MEMBER
MEMBER
ADULT 0.00
TOTAL 0.00
CATEND 6.00
CHANGE 6.00

ITEM 3
TCL 0.00

4367 08:57TM

"Great art picks up where nature ends." –Marc Chagall

Retrieving Whites

In some instances, you can "retrieve" whites by lifting out the color you've placed. Use a stiff brush or a sponge and clean water to gently scrub the surface of your paper where the intended white is located. Then lift off the loose color with a clean paper towel. If you want to retrieve a sharp edge or a highlight, try masking around the area to be lifted out to avoid affecting other parts of the composition. And if you want to lift out a very thin line or a very small amount of white—such as an eye's highlights or an animal's whiskers—you can try gently scraping the dried paint with the edge of a razor to remove the color. When using retrieving techniques, it's important to wait until you're finished painting—the paper won't accept paint smoothly again in areas where it's been disturbed.

Sketching with "Saved" Whites

When painting white objects, it's very important to plan your approach to the painting. Even though you can retrieve small portions of white late in the painting process, it's best to leave large areas of white untouched from the beginning. As I mentioned before, when painting whites, I usually begin with a value study, squinting my eyes as I view the scene to help me distinguish between the light and dark colors. Once the values are worked out, I begin my sketch by painting the negative shapes of the white subject (and the other positive elements of the painting). The idea is to progressively remove the white paper until the subject "emerges"!

Remember: The only time white truly looks white is in areas where the light is hitting the object directly. In other areas, white is full of reflected colors, taking on tinges of whatever colors are nearby. Use your artistic license to emphasize any colors you see in the shadows. If you see a hint of color in the shadows, really show the color!

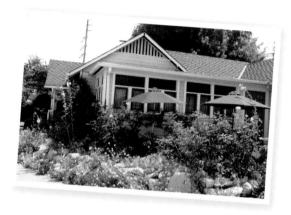

Creating Drama For a more eye-catching composition, I decide to decrease the size and prominence of the dark windows, thus opening up more white space and producing more areas of contrast for interest.

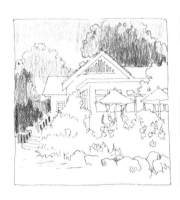

Value Study Step 1
Using a soft-leaded pencil, I begin with the negative space behind the house—the trees and sky. Adding this mid-range value makes the lighter-colored house appear to come forward.

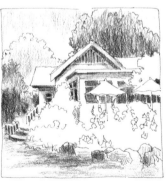

Value Study Step 2
Still applying mid-range values, I develop shadows and fill in windows. Notice I haven't touched the umbrellas, but their shape is defined by the negative space of the windows behind them.

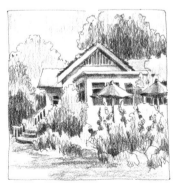

Value Study Step 3
Now I focus more on the positive shapes, lightly shading the umbrellas and flowers. I also revisit the negative spaces, adding dark values to produce a stronger contrast.

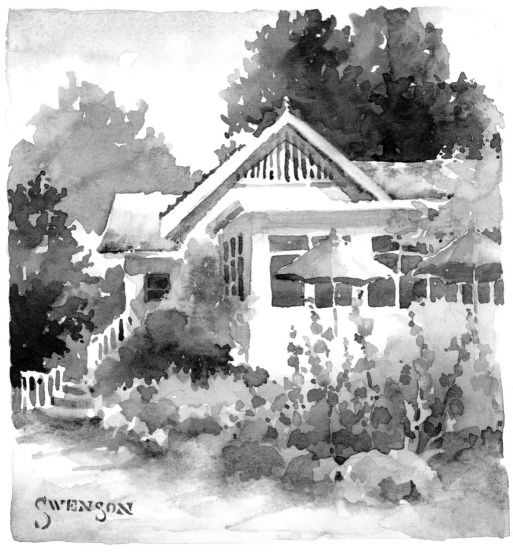

SWENSON

"The object of art is not to reproduce reality, but to create a reality of the same intensity." –Alberto Giacometti

◀ **Color Palette** Both the whites and the shadows of my sketch contain hints of the rest of my palette, which includes (clockwise from the top) quinacridone gold, orange, carmine, cobalt blue, marine blue, burnt sienna, permanent green yellowish, and lunar black (not pictured).

Working on Tinted Paper

Watercolorists often talk about "happy accidents"—those events that occur by chance but result in a pleasing circumstance. For me, happy accidents usually occur when I'm opening myself up to new possibilities, experimenting with new colors, methods, or techniques. During one such "play time," I was making a value study on a piece of colored scrap paper. My watercolor palette was nearby, prompting me to wonder how a wash of color over the drawing might look. So I added a few lights with white *gouache*—an opaque watercolor paint. And, to my delight, I discovered that I loved the result! Applying gouache to sketches on tinted paper is nothing new—but it opened up new possibilities for me!

Selecting Tinted Papers

There are many kinds of tinted papers. I've found a few companies that make tinted watercolor paper, but I find the expense unnecessary. Most surfaces I paint on are not actually intended to accept watercolor. For example, I've found that charcoal papers handle watercolor nicely, with little warping. And rice paper can also produce wonderful results. (Tip: Cover the paper with a thin wash of matte medium before painting.) I keep a variety of different types and colors of tinted papers tucked in the back of my sketchbook so they are readily available to me.

Watercolor looks beautiful on tinted paper—but even pen-and-ink renditions take on a special feel!

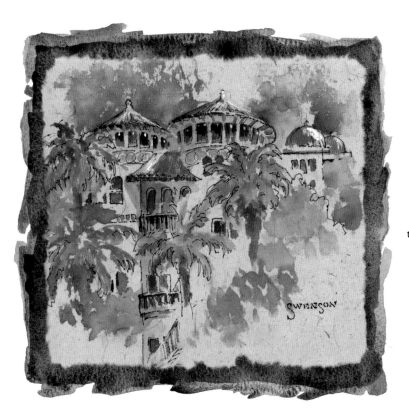

Working with Delicate Papers

When I'm working with delicate colored paper—such as the rice-paper sketch at left—I like to mount the paper on a sketchbook page for easier handling. For a special effect, sometimes I'll paint a border around the edges of the mounted paper. Remember, in a sketchbook, anything goes!

SWENSON

• THE CASTLE GREEN •
BUILT IN 1889, ORIGINALLY CALLED THE WEBSTER'S HOTEL. BOUGHT IN 1891 BY COLONEL G.G. GREEN.

Using Gouache for Your Whites

When working with colored paper, the tint of the paper acts as the mid-range value. So instead of saving the white of the paper to act as your white, you paint your whites with gouache in the same manner you paint your other light and dark values. Because gouache paints are opaque, they also allow you the freedom to try working from dark to light—applying the watercolor midtones and darks first, and saving your gouache highlights for last.

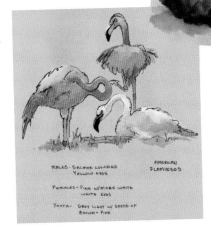

OSTRICH

MALES - SALMON COLORED
YELLOW EYES

AMERICAN
FLAMINGOS

FEMALES - PINK W/MORE WHITE
WHITE EYES

YOUTH - GREY LIGHT W/ SPOTS OF
BROWN + PINK

*"A work of art which did
not begin in emotion is not art."*
—Paul Cezanne

Sketching on Tinted Paper

Tinted paper does more than simply act as a midtone for your sketches—it also influences the colors laid on top of it, affecting the overall feel of the subject. When the tint of the paper is warm, the sketch can convey excitement, energy, or even heat. When the colored ground is cool, the paper can subdue a scene, making it seem tranquil, calm, or cold.

Tinted papers come in a variety of colors, thicknesses, and textures. Don't be intimidated—try anything that catches your eye, whether it's officially called "watercolor" paper or not.

Choose colors for your sketch that harmonize with your chosen paper, darkening any of the more transparent watercolor paints with black to help them hold their own against the gouache and the more opaque watercolors.

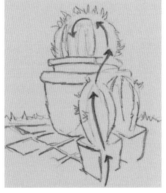

Planning Values Just as you mapped values to save your whites on regular paper, you plan your values to save your midtones on tinted paper.

Leading the Eye The paper's mid-range values guide the eye up into the painting. My goal is to keep this visual passage as unobstructed as possible.

Clearing the Corners A simple vignette leaves untouched paper that helps direct the eye.

When working on a tinted surface, the underlying color helps unify the painting.

▶ **My Palette** For this painting, I use (from top to bottom) raw sienna, manganese blue hue, cobalt blue, quinacridone sienna, burnt sienna, lunar black, and permanent white gouache. These colors contribute an overall warm feeling to the painting.

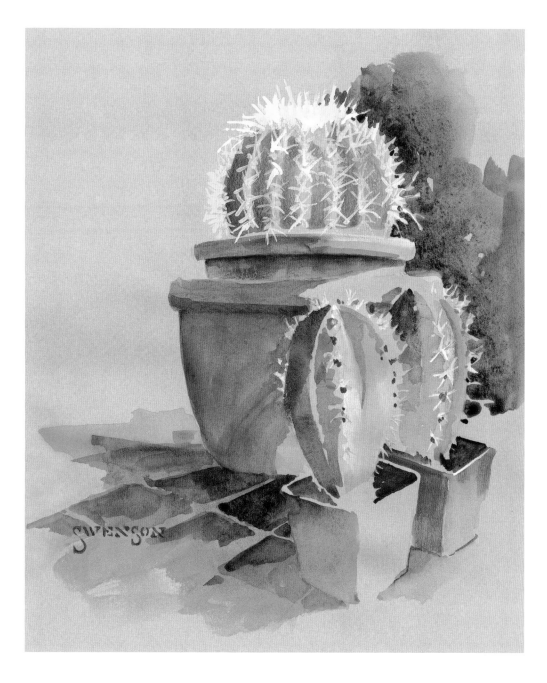

When working on tinted paper, your paint colors will be slightly altered. For example, if the surface has a blue tint, colors will seem cooler; if the paper has a yellow tint, colors will appear warmer.

Producing a Painting from a Sketch

A sketch can be an end unto itself, or it can become a bridge to a larger studio painting. My paintings speak for me—sometimes a sketch is satisfactory, encompassing all I want to say about a moment in time. But, as I'm not a fast painter, a majority of my sketches are kept small so that I can complete multiple sketches at one site. And there are other times when a small sketch awakens my interest in a subject rather than satisfying it, making me want to explore the subject matter on a larger scale. At times like these, I use my sketchbook as a springboard for developing a more complete painting in my studio. Photographs of a subject are handy for information about details, but I rely on my sketches for architectural information, local colors, shadows, and reflective light. Unlike photographs, my original sketches also telegraph my emotional reaction to a subject. After all, it's my job as an artist to breathe life into my work!

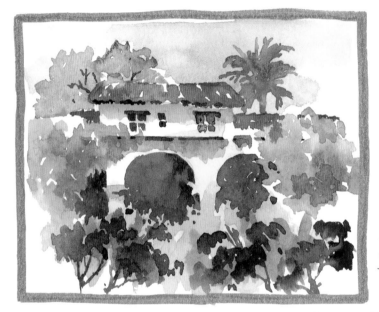

I've spent numerous days sketching at the San Juan Capistrano Mission. The light is bright and clear, the weather is mild and comfortable, and the grounds are alive with blooms of every color imaginable!

SAN JUAN CAPISTRANO
—◦MISSION◦—

THE MISSION IS SO FULL OF COLOR! EVERY PLACE I LOOK THERE ARE FLOWERS AND TREES IN FULL BLOOM.

I WAS HERE JUST DAYS AGO WITH MIKE. I DID THE FIRST SKETCH WITH HIM. BUT TODAY I RETURNED BY TRAIN TO SKETCH WITH MY PAINTING BUDDIES. THIS IS GREAT STUFF FOR INSPIRATION.

Metro Rail

Metro Gold Line
Mission

Metro Day Pass
Regular - $ 3.00

Valid: 05/21/04

Valid on Metro Bus an
Metro Rail. Not Valid
for Metro to Muni
Transfer. Zone charge
may apply on Express
Service.

TVM No. 00042
Ticket No. 0000012211

Mission San Juan Capistrano
31414 El Camino Real
San Juan Capistrano, CA 92675

05/21/04
IRMA C 09:47:18 AM
Transaction: TICKETS2
 03090R0023

1 ADULT GENERAL ADMISSION

 6.00

Subtotal 6.00
Added Tax $ 0.00
Total $ 6.00
Cash $ 11.00
Change Due $ 5.00

AMTRAK

1
SWENSON/BRENDA

From
LOS ANGELES, CA
To
SAN JUAN CAPIST, CA
2V

U UNRESERVED

V1 1702
 $12.00 $.00
 $12.00

BOB2
1380022340587 01 01
17MAY04 /TR
PASSENGER RECEIPT

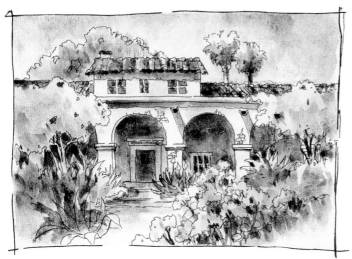

Step One

Before I begin a painting, I like to take a few minutes to compose the subject, using my sketch as a reference and making adjustments to my original design. At this stage, I may briefly refer to a photo, and I may also rearrange elements or alter the format, viewpoint, or colors. When I'm pleased with the design, I complete a detailed value study. My value studies have more information in them than many artists include, but this is what works best for me. I enjoy the act of planning a painting, and the time spent drawing allows me the opportunity to walk through the painting process in my mind before I put paint on paper.

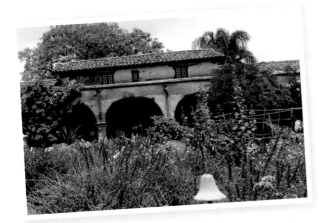

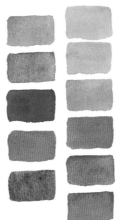

"A work of art is a personal encounter with a reality, not a copy."
—Vincent Van Gogh

▶ **Experimenting with Color** Sometimes I work out my colors before I begin painting, referring to any initial notes or swatches in my sketchbook. Here I decided on a palette including (from top of left column) manganese blue hue, cobalt blue, marine blue, quinacridone sienna, burnt sienna, new gamboge, raw sienna, quinacridone gold, scarlet lake, carmine, and rose-violet.

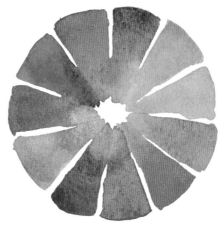

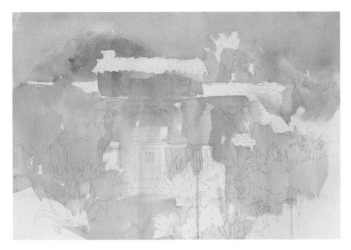

Step Two

First I lightly sketch the composition in pencil. Then I establish the local colors, covering the sky, building, and trees with light washes and allowing the colors to blend where they meet so there are no hard edges separating the elements. I take care to save white where the flowers will be placed, but I cover the majority of the paper with light values.

Step Three

Next I add the colorful foliage. For a soft, diffused look, I paint wet into wet, dampening the paper with clean water before charging in the colors individually and allowing them to blend on the paper. It is too early to think about details at this point; I simply want to establish the larger shapes and areas of color.

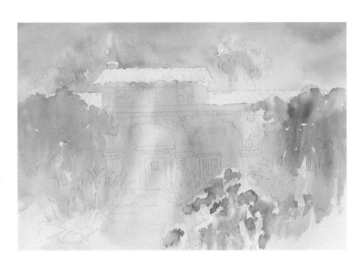

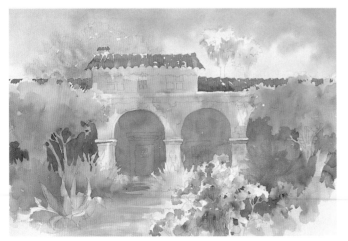

Step Four

Now I begin more detailed work, beginning with the tile roof of the building. The large shape and dark values produce a more solid feeling. Then I fill the large negative spaces of the archways with a mid-range value. I paint more carefully around the trees, defining the shapes of the trunks and branches by painting around them with the darker values.

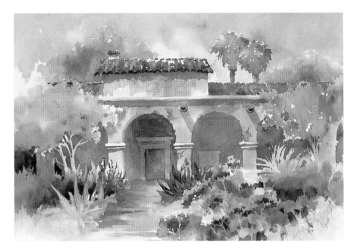

Step Five

To define the details, I again work in the negative space, first applying darker glazes inside the arches—painting around the door and window—and then suggesting the stem pattern on the foreground foliage. I also add cast shadows under the eaves. While the paint is damp, I introduce colorful reflected light to give the building a sunlit appearance.

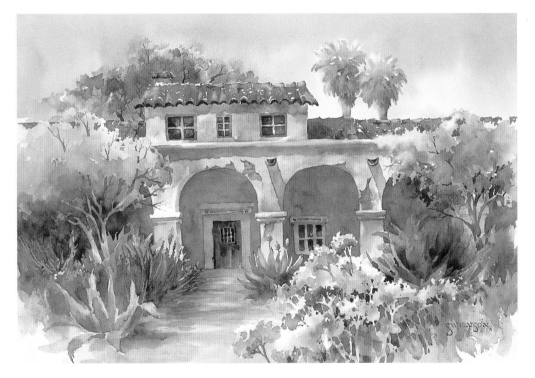

Step Six

In the final stage, it's important to think more and paint less! I make a few necessary adjustments to the values, but I don't overwork the painting with needless details. I call attention to my center of interest by placing the darkest values around the door, windows, and pathway leading to the building. I also add branches to the trees and soften the roofline using clean water and a stiff brush. That's all there is to it!

Conclusion

I have often heard people say, "It must be nice to be so gifted," which always makes me laugh a little. Yes, talent is nice, but it won't get you very far unless you develop skill. I discovered early in life that I don't really see something until I draw it. And the advice I can share with you is this: The more you sketch and paint, the stronger your own awareness will become. Before long, you'll start to observe and study the world in a new way. Even when you're just out and about taking care of daily business, you'll notice little things you never had before. These small, simple things will take on a new importance and beauty. And the presence of light and shadow will inspire the artistic spirit in you. An artist's gift isn't his or her talent—it's the ability to see and appreciate the beauty that exists in ordinary, everyday life.

Thank you for allowing me to share a portion of my world with you through this book and my sketches. My intention in creating this book is to help others develop the skills and confidence to find their own artistic voice. I hope this book has inspired you.

We honor our dreams with persistence!
Brenda Swenson

*"If people knew how hard I worked to get my mastery,
it wouldn't seem so wonderful at all." —Michelangelo*